Baz Luhrmann

BAZ LUHRMANN

Reimagining Classics for a New Generation-Cinematic Extravagance

Maxy M. Max

Baz Luhrmann

All rights reserved. No part of this publication may be reproduced, distributed, or transmitted in any form or by any means, including photocopying, recording, or other electronic or mechanical method, without the prior written permission of the publisher, except in the case of brief quotations embodied in critical reviews and certain other noncommercial uses permitted by the copyright law.

Copyright © Maxy M. Max, 2024.

Baz Luhrmann

TABLE OF CONTENTS

INTRODUCTION

CHAPTER 1: WHO IS BAZ LUHRMANN

Early life and background

First Steps into Filmmaking

CHAPTER 2: A BOLD BEGINNING – STRICTLY BALLROOM (1992)

Themes of Love, Dance, and Rebellion

Critical Reception and International Success

CHAPTER 3: ROMEO + JULIET (1996) – SHAKESPEARE FOR A MODERN WORLD

The Concept of Modernizing a Timeless Classic

Casting and Visual Styling: A Radical Approach

Music and Symbolism: The Soundtrack as a Narrative Tool

CHAPTER 4: MOULIN ROUGE! (2001) – A MARRIAGE OF MUSIC AND FANTASY

The Role of Music and Artifice in Storytelling

Iconic Performances: Nicole Kidman and Ewan McGregor

Baz Luhrmann

CHAPTER 5:AUSTRALIA (2008) – A CINEMATIC EPIC

Reception and Analysis: A Commercial and Critical Crossroad

CONCLUSION

Baz Luhrmann

INTRODUCTION

Baz Luhrmann is a rare visionary in the world of filmmaking, known for his groundbreaking approach to storytelling that electrifies audiences and breathes new life into timeless tales. With a signature style defined by bold visuals, eclectic soundtracks, and a theatrical sense of drama, Luhrmann has become synonymous with cinematic extravagance. From his daring take on Shakespeare in Romeo + Juliet to the spellbinding spectacle of Moulin Rouge!, Luhrmann transforms each film into an immersive experience, blending classic themes with a modern sensibility that resonates with new generations.

Born in Australia, Luhrmann's roots in theater and dance shaped his creative ethos and paved the way for a film career that defies convention. His journey from an aspiring actor to a director with a global impact was fueled by a relentless passion for storytelling and a drive to challenge the boundaries of what film could be. He

Baz Luhrmann approaches his projects not simply as films but as cultural experiences, blending genres and manipulating time and place to create worlds where classic narratives become accessible, engaging, and deeply emotional.

In Baz Luhrmann: Reimagining Classics for a New Generation – Cinematic Extravagance, we explore the evolution of his career, the influences that have shaped his distinct style, and the artistry behind his most celebrated works. Each chapter delves into the intricate process that goes into crafting a Luhrmann film, from visual design to music curation, and the ways in which he reinterprets beloved stories for contemporary audiences.

Luhrmann's films are as much about the sensory journey as they are about the story. He takes familiar characters and plots and transforms them, layering them with dazzling visuals and soundscapes that draw viewers into a visceral experience. His creative choices not only appeal to those who crave originality in cinema but also invite audiences to see timeless stories through a new

Baz Luhrmann

lens. By reimagining classics with such fearless originality, Luhrmann has forged a legacy that challenges, inspires, and celebrates the transformative power of art.

This book is a tribute to the man who has redefined storytelling for the modern age. It captures Baz Luhrmann's ability to create magic on screen, his dedication to reinterpreting the classics, and his commitment to offering audiences a cinematic journey like no other.

Baz Luhrmann

CHAPTER 1: WHO IS BAZ LUHRMANN

Baz Luhrmann is an Australian filmmaker, screenwriter, and producer, renowned for his distinctive and highly stylized approach to filmmaking. He is best known for his work on visually extravagant and emotionally charged films that blend music, dance, and vivid color schemes, often with a modern sensibility. His signature style combines elements of drama, romance, and spectacle with a sense of heightened reality.

Luhrmann's breakthrough came with Strictly Ballroom (1992), a romantic comedy-drama about the world of competitive ballroom dancing. The film was a success both in Australia and internationally, establishing him as a unique voice in cinema.

He continued to make waves with Romeo + Juliet (1996), a modernized version of Shakespeare's Romeo and Juliet, set in a contemporary urban environment but maintaining the original dialogue. The film was a bold

Baz Luhrmann

and innovative take on the classic tragedy, introducing a new generation of viewers to Shakespeare.

In 2001, Luhrmann directed Moulin Rouge!, a musical that became an instant hit, celebrated for its vibrant visuals, musical numbers, and unconventional storytelling. The film's use of modern pop songs in a period setting, alongside its extravagant costumes and sets, solidified Luhrmann's place as a master of spectacle and emotional storytelling.

Other notable films by Baz Luhrmann include Australia (2008), a period epic starring Nicole Kidman and Hugh Jackman, and The Great Gatsby (2013), a visually stunning adaptation of F. Scott Fitzgerald's novel, featuring Leonardo DiCaprio. More recently, he directed Elvis (2022), a biographical film about the legendary musician Elvis Presley, which received critical acclaim for its energetic portrayal of Presley's life and career.

Throughout his career, Luhrmann's work has been marked by his unique ability to blend genres, manipulate

Baz Luhrmann

time, and create memorable cinematic moments, often using music and visuals to convey emotional depth. His films often explore themes of love, ambition, and personal transformation.

Early life and background

Baz Luhrmann was born Mark Anthony Luhrmann on September 17, 1962, in Sydney, Australia, into a family that would eventually influence his creative journey. His early life was shaped by his parents' diverse backgrounds—his mother was a ballroom dance teacher, and his father was a high school teacher. Growing up in a suburban area of Sydney, Luhrmann was introduced to the world of performance and artistic expression early on, particularly through his mother's ballroom dancing. These early experiences with movement and music became an integral part of his future filmmaking style, where the visual and auditory elements play a key role.

Baz Luhrmann

As a child, Luhrmann was drawn to the arts, developing an interest in both acting and the visual arts. He attended the prestigious National Institute of Dramatic Art (NIDA) in Sydney, a breeding ground for Australia's best acting talent. While at NIDA, Luhrmann's ambition and creativity set him apart. His time there was marked by an interest in not only acting but also in directing and producing, showing an early affinity for the role of storyteller.

After graduation, Luhrmann's early career in the theater included work in experimental theater, where he began to refine his signature visual style—vibrant, exaggerated, and immersive. His theatrical background would later become a defining feature of his films. His first major success came with Strictly Ballroom (1992), which was initially conceived as a stage play before being adapted into a film. The success of Strictly Ballroom was a turning point, launching him into international fame and cementing his ability to fuse music, movement, and emotion into a cinematic spectacle.

Baz Luhrmann

Baz Luhrmann's background, steeped in both the performing arts and visual experimentation, gave him a unique perspective on filmmaking. This foundation of artistic exploration and his exposure to different forms of storytelling—whether through dance, theater, or music—allowed him to revolutionize how audiences engage with cinema, often blending classical themes with contemporary sensibilities.

His upbringing in Australia, surrounded by a strong cultural respect for the arts, combined with the influences of his parents, laid the groundwork for a career that would push boundaries and leave a lasting impact on the world of film. Luhrmann's early life was a tapestry of artistic influences, all of which would converge to shape him into the visionary filmmaker known for his bold, visually striking, and emotionally resonant films.

Baz Luhrmann

First Steps into Filmmaking

Baz Luhrmann's journey into filmmaking is a fascinating tale of creativity, ambition, and an unwavering desire to break the norms of conventional storytelling. Born Mark Anthony Luhrmann in Sydney, Australia, in 1962, his path to becoming one of the most distinctive voices in modern cinema was not a straightforward one. Luhrmann's early years were shaped by a diverse range of influences, from the world of theater to the visual arts, all of which would later inform his approach to filmmaking.

Before stepping into the realm of cinema, Luhrmann's artistic inclinations were nurtured through his studies at the National Institute of Dramatic Art (NIDA) in Sydney, where he trained as an actor. However, his passion for storytelling quickly transcended the stage. This shift was marked by a realization that filmmaking allowed him to create worlds entirely of his own design, combining music, performance, and visuals into a singular,

Baz Luhrmann

immersive experience. His exposure to avant-garde theater and experimental arts pushed him to think of filmmaking as a broader canvas, where every frame could tell a story, and every element could serve as a means of expression.

His initial foray into the film industry came not through an established career but as an independent filmmaker with a vision of doing things differently. Luhrmann's early work began in the world of television and advertising, where he honed his ability to create visually compelling narratives. It was during these formative years that he first experimented with the fast-paced, visually rich style that would become his signature. His experiences in television commercials allowed him to master the art of brevity and impact, skills that would later serve him well in the world of feature filmmaking.

However, it was his first feature film, Strictly Ballroom (1992), that truly marked the beginning of his career as a director. The film was a gamble, born from a desire to tell an unconventional story of love, rebellion, and

Baz Luhrmann

self-expression within the context of the competitive world of ballroom dancing. Luhrmann, who co-wrote the screenplay with Craig Pearce, sought to break free from traditional storytelling conventions, creating a world where the rules of dance were both literal and symbolic of larger themes of individuality and defiance.

In Strictly Ballroom, Luhrmann's direction was bold and energetic, using vivid color palettes, quick cuts, and heightened performances to create a visual style that was anything but conventional. The film's tone was a mix of satire and earnestness, showcasing his ability to balance humor with deeper emotional undercurrents. Though Strictly Ballroom was not initially a massive commercial hit, it gained a cult following and received critical acclaim for its originality. It was a clear statement that Luhrmann was not interested in following trends but in establishing his own cinematic language.

The film's success also helped Luhrmann build a reputation as a director who wasn't afraid to take risks, and it laid the foundation for his future works, which

Baz Luhrmann

would continue to explore bold, extravagant narratives. His instinct for blending genres and pushing the boundaries of visual storytelling would soon be evident in Romeo + Juliet (1996), Moulin Rouge! (2001), and beyond.

Luhrmann's first steps into filmmaking can be characterized by his eagerness to reinvent traditional genres and his commitment to crafting films that felt both contemporary and timeless. His unique vision was driven not just by a desire to entertain but by a passion for reimagining the classics and presenting them in a way that would resonate with modern audiences. Through his early works, Baz Luhrmann established himself as an artist who sought to transform the language of cinema, laying the groundwork for a career that would redefine the cinematic landscape.

Baz Luhrmann

CHAPTER 2: A BOLD BEGINNING – STRICTLY BALLROOM (1992)

Strictly Ballroom (1992) marked a bold and defining moment in Baz Luhrmann's filmmaking career, establishing him as a director with a distinct voice and a unique approach to storytelling. The film was his first feature and set the stage for what would become a career marked by visually extravagant, emotionally charged, and genre-defying works. The story of Strictly Ballroom revolves around the world of competitive ballroom dancing, but its themes and tone transcend the dance floor, exploring ideas of individuality, conformity, and the pursuit of artistic expression.

Luhrmann's vision for Strictly Ballroom was rooted in his desire to push the boundaries of traditional storytelling and his passion for theater, performance, and spectacle. He sought to create a film that was not only entertaining but also deeply expressive in its use of

Baz Luhrmann

visual style, music, and character development. Drawing from his background in theater, where he had been involved in the production of plays, Luhrmann brought an exaggerated, almost surreal approach to his direction. The characters in Strictly Ballroom are larger-than-life, and the world they inhabit is hyperreal, creating a kind of heightened reality where the lines between fantasy and real life blur.

One of the most striking elements of the film is its visual style. Luhrmann, along with his collaborators, crafted a world that was brimming with vibrant color, elaborate costumes, and highly stylized choreography. The film's bold, saturated color palette was not just a visual choice but a way to reflect the emotional intensity of the characters and their desires. The cinematography used sweeping camera movements, quick cuts, and dramatic close-ups to enhance the emotional stakes of each moment, particularly during the dance sequences, where the choreography itself became a form of emotional expression.

Baz Luhrmann

The film's plot revolves around Scott Hastings, a talented but rebellious young dancer who refuses to follow the rigid rules of competitive ballroom dancing. His refusal to conform to the strict expectations of the dance world sets him on a collision course with his overbearing mother, his traditional dance partner, and the controlling dance community. The romance between Scott and Fran, a shy, awkward dancer played by Tara Morice, is at the heart of the film. Fran, in many ways, represents the spirit of individuality and freedom that Scott is searching for. Their relationship, both on and off the dance floor, becomes a metaphor for defying the constraints placed on them by society and the world they inhabit.

The underlying themes of Strictly Ballroom—individuality, self-expression, and the desire to break free from the expectations of others—resonate beyond the context of competitive dancing. Luhrmann used the sport of ballroom dancing as a metaphor for the pressures of conformity in society. The structured and highly regulated world of competitive dancing serves as

Baz Luhrmann

a microcosm for a broader cultural struggle, where tradition and authority often clash with the desire for personal freedom and artistic innovation. Scott's defiance of the rules mirrors the larger narrative of youthful rebellion against an oppressive system, a theme that would continue to inform Luhrmann's work in the years that followed.

The film also introduced audiences to a key element of Luhrmann's style: the seamless integration of music into the storytelling. Music in Strictly Ballroom is not simply a backdrop to the action; it drives the emotional narrative and accentuates the intensity of key moments. The film's soundtrack features a mix of popular music and original compositions, with tracks like "Love is in the Air" becoming iconic in their association with the film. Music is integral to the dance sequences, where the rhythm and beat of the songs mirror the characters' emotional arcs, making each dance a powerful expression of their inner struggles and desires.

Baz Luhrmann

Although Strictly Ballroom did not initially achieve major box office success, it quickly became a cult hit and was widely praised for its originality. Critics and audiences alike were drawn to its unique mix of humor, heart, and visual flair. The film won several awards, including the prestigious Australian Film Institute Award for Best Film, and it cemented Luhrmann's reputation as a filmmaker willing to take risks and challenge cinematic norms. It also introduced the world to his bold approach to storytelling, which combined grand spectacle with deep emotional resonance.

The film's success can also be attributed to its strong performances. Paul Mercurio, who played Scott, brought an intense charisma to the role, embodying the character's internal conflict with depth and sincerity. Tara Morice's portrayal of Fran was equally captivating, capturing the character's journey from awkwardness to self-confidence in a way that resonated with viewers. The supporting cast, including Bill Hunter as the stern dance instructor and Pat Thompson as Scott's meddling mother, added layers of complexity to the film's

Baz Luhrmann

ensemble, creating a dynamic that felt both comical and poignant.

Strictly Ballroom was more than just a film about dance; it was a statement about the power of artistic expression, the importance of breaking free from societal constraints, and the value of individuality. The film's message of self-empowerment and defiance of tradition would become recurring themes in Luhrmann's later works, including Romeo + Juliet, Moulin Rouge!, and The Great Gatsby. Through Strictly Ballroom, Luhrmann demonstrated that cinema could be both visually captivating and thematically rich, using artifice and spectacle to convey deep emotional truths.

Ultimately, Strictly Ballroom established Baz Luhrmann as a filmmaker with a unique voice and a bold vision for cinema. The film not only launched his career but also reshaped the way audiences thought about the potential of film as an art form. Luhrmann's ability to merge extravagant visuals with heartfelt stories would become a hallmark of his filmmaking style, one that would

continue to evolve and captivate audiences for decades to come.

Themes of Love, Dance, and Rebellion

In Strictly Ballroom (1992), Baz Luhrmann weaves together the themes of love, dance, and rebellion into a vibrant tapestry, creating a film that resonates with audiences on both an emotional and visual level. These themes are not merely superficial elements of the plot but serve as the driving forces behind the narrative, symbolizing deeper ideas about self-expression, societal expectations, and the transformative power of artistic freedom.

At the heart of the film is the theme of love, which is portrayed not just as a romantic connection but as a broader force that challenges the boundaries of tradition and conformity. The romance between Scott Hastings,

the rebellious ballroom dancer, and Fran, an overlooked and initially awkward young woman, is at the core of the film's emotional journey. Their relationship represents a meeting of two worlds: Scott's desire to break free from the constraints of the competitive dance world and Fran's quiet longing for self-expression. In the context of their love story, dance becomes both a metaphor for their personal growth and an expression of their emotions. As their bond deepens, it transcends the boundaries of the dance floor, symbolizing a broader struggle against the pressures of society and the strict norms that attempt to define them.

Love in Strictly Ballroom is also about the courage to defy what others expect of you. Scott's love for Fran is, in part, a rejection of the world around him, particularly the rigid, rule-bound world of competitive ballroom dancing. His willingness to dance with Fran, despite her lack of experience, is a form of rebellion against the standards of perfection imposed by the dance community. In turn, Fran's love for Scott is a journey of self-discovery. Her quiet confidence and her

Baz Luhrmann

transformation from an awkward outsider to a more self-assured individual are enabled by their partnership. Their love becomes a vehicle for self-expression, both in the literal sense of their dancing and in the symbolic sense of their personal and emotional growth.

Dance in the film serves as a powerful medium for expressing identity and emotion. It is a language that transcends words, a form of communication that speaks to the heart and soul. For the characters in Strictly Ballroom, dance is not just an art form but a means of personal liberation. Scott's frustration with the rigid rules of competitive ballroom dancing is rooted in his desire to express himself authentically, rather than adhere to the cookie-cutter standards set by the dance community. In his eyes, the art of dance should be about personal expression, not about perfection. This tension between expression and conformity is central to the narrative, as Scott becomes more determined to redefine the way ballroom dance is performed.

Baz Luhrmann

For Fran, dance is initially a path to acceptance and recognition. Her unpolished moves symbolize her own lack of self-confidence, but as she finds herself through Scott's guidance, her dancing evolves into an expression of inner strength and individuality. The iconic final dance sequence, in which Scott and Fran perform their unconventional routine, becomes a symbol of their emotional and artistic liberation. It is a defiant act against the established norms, a celebration of the joy and freedom that can come from embracing who you truly are. In this sense, dance is portrayed as a transformative, almost magical force—one that allows individuals to break free from the restrictions placed on them by society.

The theme of rebellion runs throughout the entire film, with characters constantly challenging the status quo in various ways. Scott is the embodiment of rebellion, both in his refusal to follow the dance world's rigid rules and in his pursuit of an authentic, self-defined identity. His desire to break free from the world of ballroom dancing mirrors a broader social and cultural desire for individual

Baz Luhrmann

freedom and expression. This rebellion is not just about defying authority for the sake of it; it is about fighting for one's right to be true to oneself. Scott's journey is about rejecting the mold that has been forced upon him by his family, his dance partner, and the competitive dance world, and instead, embracing his own vision for what dance—and life—can be.

Fran, while not initially as outwardly rebellious as Scott, undergoes her own transformation throughout the film. Her rebellion is more subtle but just as powerful. She is initially an outsider, someone who doesn't quite fit into the rigid, glamorous world of competitive ballroom dancing. Her willingness to break away from convention and embrace her own unique style of dancing becomes her own act of defiance. Her journey is about finding her voice and asserting her individuality, both on the dance floor and in her personal life. In this sense, her rebellion is about self-empowerment and self-acceptance, and her relationship with Scott becomes a catalyst for her transformation.

Baz Luhrmann

Rebellion in Strictly Ballroom is also portrayed through the broader societal context. The film critiques the way in which traditions, rules, and conventions can stifle creativity and individuality. The ballroom dance world in the film is depicted as a place of control, where every movement is prescribed, and personal expression is discouraged. The desire to break free from these constraints is universal, and it resonates with anyone who has ever felt trapped by the expectations of others. Luhrmann uses this world of dance to explore the ways in which society often places limitations on individuals, especially those who seek to defy expectations and chart their own path.

Strictly Ballroom also highlights the importance of finding your own voice, and the film suggests that rebellion does not always have to be loud or disruptive. Sometimes, it is a quiet act of courage, a small step toward self-expression that can lead to monumental change. The film's characters may not all be radical in their defiance, but their actions reflect a deep desire for autonomy and authenticity. The rebellion in the film is

ultimately about reclaiming agency, whether through love, dance, or the simple act of choosing to be yourself in the face of societal pressure.

In Strictly Ballroom, Baz Luhrmann skillfully intertwines the themes of love, dance, and rebellion, creating a narrative that is both entertaining and deeply meaningful. Through these themes, the film becomes more than just a story about ballroom dancing; it becomes a celebration of the human spirit's capacity for defiance, growth, and self-expression. The film's lasting impact lies in its portrayal of the transformative power of love and the courage required to reject conformity in favor of personal authenticity.

Critical Reception and International Success

Baz Luhrmann's Strictly Ballroom (1992) was met with an enthusiastic reception from both critics and audiences,

Baz Luhrmann

establishing him as a unique and innovative filmmaker whose work resonated with a broad international audience. Though the film was initially a modest success in Australia, it went on to become a worldwide phenomenon, garnering critical acclaim and solidifying its place as a cultural touchstone. The film's mix of exuberant visuals, compelling characters, and subversive themes earned it praise for its originality, with Luhrmann's bold vision shining through in every frame.

The film's critical reception in Australia was overwhelmingly positive, and it quickly became a beloved classic in the country. Australian critics lauded Luhrmann for his fresh and innovative approach to filmmaking, which blended the flamboyance of performance with deeply relatable themes of individualism and rebellion. The film's success was also attributed to its ability to capture the essence of Australian culture, particularly through the lens of competitive ballroom dancing, a world often perceived as overly formal and reserved. Luhrmann's decision to subvert this world with vibrant colors, exaggerated

performances, and a playful yet heartfelt narrative resonated with Australian audiences, who saw in the film a reflection of their own desire to break free from the constraints of tradition.

In addition to the positive reception from local critics, Strictly Ballroom also garnered attention on the international stage. When the film premiered at the Cannes Film Festival in 1992, it was met with rapturous applause, drawing significant attention from international film markets. The film's dazzling visuals, energetic performances, and witty script stood out in the crowded festival, earning it a reputation as a standout feature. Critics abroad were quick to recognize the film's universal appeal, even though it was rooted in the distinctly Australian tradition of ballroom dancing. The themes of rebellion, love, and personal expression struck a chord with audiences from various cultural backgrounds, transcending national borders.

The film's international success can also be attributed to its ability to balance spectacle with heart. While its

Baz Luhrmann

visual exuberance and over-the-top style were immediately eye-catching, Strictly Ballroom was also lauded for its emotional depth and its heartfelt portrayal of characters who were grappling with universal themes. The character of Scott Hastings, played by Paul Mercurio, became an icon for those who saw in him a symbol of youthful defiance and the desire to break free from the suffocating expectations of society. Fran, played by Tara Morice, was similarly praised for her transformation from an awkward and overlooked dancer into a confident and self-assured individual. The film's central love story, though set against the backdrop of the dance world, resonated on a deeper emotional level, making it relatable to audiences far beyond Australia.

As Strictly Ballroom gained traction overseas, it became a cultural touchstone for filmgoers in countries around the world. The film's unique blend of humor, romance, and drama, coupled with its memorable soundtrack, made it a hit in markets including the United States, the United Kingdom, and Europe. In particular, the film's release in North America marked a turning point in

Baz Luhrmann

Luhrmann's career. The film was embraced by American audiences, who were captivated by its humor, charm, and bold visual style. It was here that Strictly Ballroom earned its reputation as a cult classic, with fans flocking to theaters to experience its unapologetic flamboyance and its messages of personal freedom and self-expression.

The film's commercial success was also a key factor in its international appeal. Though it had a modest budget, Strictly Ballroom grossed over $20 million globally, a significant achievement for an Australian film at the time. The film's financial success opened doors for Luhrmann, who had quickly proven that he was capable of blending artistic vision with commercial viability. This success also brought Luhrmann to the attention of Hollywood, where his distinct style would soon earn him the opportunity to direct larger-scale projects, such as Romeo + Juliet (1996) and Moulin Rouge! (2001).

One of the key aspects of Strictly Ballroom's international success was its ability to be embraced by a

Baz Luhrmann

wide demographic. The film's themes of rebellion and the pursuit of personal authenticity struck a chord with both younger and older audiences. Young viewers related to the film's message of defying societal norms and discovering one's true self, while older generations saw it as a nostalgic reflection on the pressures of tradition and conformity. This broad appeal allowed the film to transcend cultural and generational divides, making it accessible to anyone who had ever felt constrained by the expectations placed upon them.

The film's international success also sparked interest in Australian cinema more broadly, helping to promote a wave of Australian films that followed in its wake. Strictly Ballroom was a significant part of the Australian New Wave of the 1990s, a movement that brought global attention to Australian filmmakers and actors. Luhrmann's film helped to showcase the diverse and rich cultural landscape of Australia, presenting a vision of the country that was both unique and universal. This helped establish Australian cinema as a force to be reckoned with on the international stage.

Baz Luhrmann

In the years following its release, Strictly Ballroom continued to gain new fans through home video and television broadcasts, further cementing its place in popular culture. The film's lasting impact can be seen in its continued influence on filmmakers, dancers, and audiences alike. Luhrmann's ability to blend high art with pop culture, combining visual spectacle with emotional resonance, became a hallmark of his career, and Strictly Ballroom stands as a testament to his ability to capture both the grandiose and the intimate aspects of human experience.

In terms of accolades, Strictly Ballroom received numerous awards and nominations, further solidifying its critical and international success. It won several prestigious awards at the Australian Film Institute (AFI) Awards, including Best Film and Best Director, and it was also recognized with several nominations at the BAFTA and Golden Globe Awards. These accolades, combined with its box office success, affirmed

Baz Luhrmann

Luhrmann's standing as an exciting new voice in international cinema.

Ultimately, the critical reception and international success of Strictly Ballroom were a clear indication of Baz Luhrmann's potential as a filmmaker. The film not only established his unique voice but also demonstrated his ability to create a cinematic experience that resonated globally. His mix of spectacle, heart, and subversion of tradition would become the hallmark of his later works, and Strictly Ballroom remains an important starting point in his exploration of the boundaries of film as both art and entertainment. The film's success heralded the arrival of a director whose boldness and creativity would leave an indelible mark on the world of cinema.

Baz Luhrmann

CHAPTER 3: ROMEO + JULIET (1996) – SHAKESPEARE FOR A MODERN WORLD

Baz Luhrmann's Romeo + Juliet (1996) marked a significant turning point in both his career and in the way classic literature was approached in contemporary cinema. By adapting William Shakespeare's Romeo and Juliet into a modern-day setting while maintaining the original dialogue, Luhrmann created a unique cinematic experience that appealed to a young audience, reimagining one of the most well-known tragedies in literary history for a new generation. His vision for the film was nothing short of revolutionary—infusing Shakespeare's timeless story of love, fate, and family feud with an exuberant, fast-paced, and visually arresting style that brought the play into the 20th century while staying true to its emotional core.

At the heart of Luhrmann's Romeo + Juliet is a commitment to preserving the purity of Shakespeare's

Baz Luhrmann

language. Unlike many adaptations that update the dialogue or completely alter the structure of the source material, Luhrmann chose to retain the original text of the play, allowing the eloquence and beauty of Shakespeare's words to remain intact. However, he made bold choices in other aspects of the production, such as the setting, costumes, and the overall aesthetic, to make the material feel fresh, vibrant, and relevant to contemporary audiences. By doing so, Luhrmann bridged the gap between the old and the new, bringing Shakespeare's timeless tale to life in a way that resonated with young viewers who may have found the original language difficult or inaccessible.

The film is set in a modern, fictionalized version of Verona, a city that resembles a chaotic, hyper-stylized version of a contemporary urban environment. The Capulets and Montagues, traditionally noble families in Shakespeare's play, are reimagined as rival business empires—Capulet Industries and Montague Corporation—engaged in a bitter, violent feud. This modernization of the setting serves as a way to

Baz Luhrmann

contextualize the ancient conflict for modern audiences, turning it into a familiar struggle between corporate power, social status, and class division. The violent clashes between the two families are depicted not with swords, but with guns, in a setting that feels at once contemporary and surreal, a hallmark of Luhrmann's distinct visual style.

The characters themselves are also given a modern makeover. Romeo (played by Leonardo DiCaprio) is transformed into a brooding, rebellious teenager, who is as much a symbol of youth and passion as he is an heir to the Montague family fortune. His aesthetic is tied to the film's larger visual scheme, with flashy Hawaiian shirts, oversized sunglasses, and a youthful, almost punk sensibility. Juliet (played by Claire Danes), on the other hand, is portrayed as a young woman caught between the oppressive expectations of her family and her desire for freedom. The character of Juliet is more than just a lovesick teenager in Luhrmann's version; she is a modern, complex figure who is searching for her own identity in a world that does not fully understand her.

Baz Luhrmann

Both characters are symbols of youth and rebellion, and their passionate love affair serves as a counterpoint to the violence and chaos that surrounds them.

The casting of DiCaprio and Danes was another stroke of genius, as both actors were in the midst of rising careers and brought a sense of youthful intensity to their roles. DiCaprio, already becoming a household name after Titanic (1997), was the perfect embodiment of Romeo's volatile emotions—simultaneously dreamy, impulsive, and deeply sensitive. Danes, known for her breakout role in My So-Called Life, brought a quiet strength to Juliet, portraying a young woman whose love for Romeo transcends the traditional expectations of her family and society. Their chemistry on screen was undeniable, making their tragic romance all the more poignant.

One of the most striking features of Luhrmann's adaptation is its visual style, which is a hallmark of his filmmaking approach. The film is a sensory overload, with every frame bursting with color, movement, and

Baz Luhrmann

energy. Luhrmann uses fast cuts, vivid imagery, and unconventional camera angles to create a dynamic and heightened cinematic experience. The modern setting is fused with Baroque architecture and religious iconography, blending old and new in a way that feels both disorienting and exhilarating. The streets of Verona are depicted as an urban labyrinth of neon lights, flashy cars, and expansive billboards, which visually underscores the chaos and confusion in the characters' lives. The film is a visual feast, with every shot meticulously composed to convey the emotional undercurrents of the story.

The soundtrack of Romeo + Juliet also played a crucial role in its success, and Luhrmann's choice of music was as groundbreaking as his visual style. The film's score features an eclectic mix of contemporary music, including songs by artists like Radiohead, The Cardigans, and Garbage, which were combined with traditional classical music to create a soundtrack that felt both timeless and modern. The music serves as a bridge between Shakespeare's Elizabethan world and the

Baz Luhrmann

modern-day, amplifying the emotional stakes of the characters' love story. The haunting use of "Kissing You" by Des'ree, for example, during the film's pivotal love scenes, became synonymous with the film and added another layer of depth to the tragic romance.

Luhrmann's approach to the play also allowed for a more accessible interpretation of the original material. By setting the story in a modern context, he made Shakespeare's themes of family loyalty, love, fate, and violence more immediate and relatable. The central conflict, which in Shakespeare's time may have seemed like an ancient, aristocratic struggle, is made relevant to contemporary audiences by placing it in a world where gang violence, family loyalty, and the rebellion of youth are pressing social issues. In doing so, Luhrmann emphasized the universality of the themes in Romeo and Juliet, showing how the story's emotional power transcends time and place.

The film also explores the concept of fate, one of the central themes of Shakespeare's play. Luhrmann portrays

Baz Luhrmann

fate as an unstoppable, often violent force that drives the characters toward their inevitable tragic end. The film's frequent use of religious imagery, such as crosses and references to angels and devils, underscores the sense of destiny that seems to control the characters' lives. Romeo and Juliet, despite their best efforts, are caught in a web of fate that ultimately leads to their demise. The film presents their love not as a sweet, innocent romance but as a doomed affair, one that is powerful and transcendent but also inevitably tragic.

Romeo + Juliet was met with mixed critical reviews upon its release, with some praising its bold approach and others criticizing its departure from traditional interpretations of Shakespeare's work. However, the film was a commercial success, grossing over $140 million worldwide, and it introduced a whole new generation to the story of Romeo and Juliet. The film became a cultural phenomenon, influencing fashion, music, and filmmaking, and it remains one of Luhrmann's most recognized and beloved works.

Baz Luhrmann

In conclusion, Baz Luhrmann's Romeo + Juliet (1996) redefined what an adaptation of a classic could be. By taking Shakespeare's timeless tale of love and tragedy and setting it in a contemporary, stylized world, Luhrmann made the play accessible to a new generation while maintaining its emotional depth. The film's innovative approach to both its visual style and its music, along with its modern interpretation of classic themes, ensured its place as a groundbreaking film that bridged the gap between past and present, making Shakespeare's work relevant to a modern audience.

The Concept of Modernizing a Timeless Classic

Baz Luhrmann's Romeo + Juliet (1996) is not merely an adaptation of William Shakespeare's timeless play but an exploration of how the essence of a classic can be modernized for a new audience while preserving its fundamental emotional and thematic core. Luhrmann's

Baz Luhrmann

concept of reimagining a work as iconic and deeply rooted in history as Romeo and Juliet was a bold artistic decision. He didn't just update the setting; he made the language and themes of Shakespeare resonate within the context of contemporary life, elevating the tragedy of the story into a vivid, urgent reflection of modern society.

At its heart, Romeo + Juliet is a story of youthful love, family feuds, fate, and violence—universal themes that continue to have relevance today. However, the play's Elizabethan origins, its archaic language, and its historical context could have easily alienated modern audiences. This is where Luhrmann's genius lies: he recognized that the power of Shakespeare's work transcends the period it was written in and, through the lens of modern sensibilities and sensorial aesthetics, he presented the play in a way that captured both the emotional intensity of the original and the energy of contemporary culture.

The first and most noticeable transformation in Romeo + Juliet is its setting. Luhrmann famously set the film in a

Baz Luhrmann

modern, fictionalized version of Verona—a bustling urban city that feels like a chaotic, hyperrealistic version of a contemporary metropolis. Gone are the lush, romantic streets of Shakespeare's Verona; instead, we find a world saturated with neon lights, oversized billboards, and a frenetic pace that mirrors the characters' emotional volatility. In this modernized setting, the feuding families, the Montagues and the Capulets, are no longer aristocratic families vying for power but corporate empires involved in a high-stakes battle for dominance in the modern world. The transition from swords to guns, the use of branded firearms instead of traditional weapons, and the general sense of urban warfare emphasize how timeless human conflict can manifest itself in different forms across generations.

This modern approach doesn't simply update the aesthetics or the milieu of the story; it intensifies its relevance. By placing the families in the realm of modern corporate culture, Luhrmann taps into the tensions that pervade today's world—class division, corporate greed, and the collapse of moral boundaries in

Baz Luhrmann

pursuit of power. In doing so, he allows the timeless themes of rivalry and division to be presented as much more than ancient grievances. In this version of Verona, the rivalry between the Montagues and Capulets feels as immediate as gang violence or corporate wars, making the tragedy of the young lovers even more poignant. The intensity of the feud, which once seemed like an age-old conflict in the original play, now feels like a universal tale of young people trapped in the crossfire of a never-ending war, one that they didn't create but are fated to die within.

Another layer of modernization in Luhrmann's adaptation comes in the form of its characters, who are reimagined as vibrant, multi-dimensional figures living in the fast-paced, consumer-driven world of the 1990s. Romeo, played by Leonardo DiCaprio, is a quintessential '90s teenager—rebellious, brooding, and emotionally driven. He is no longer a young nobleman with poetic speeches but a passionate, impulsive figure shaped by contemporary youth culture. He wears Hawaiian shirts and carries a gun in a holster, and his

Baz Luhrmann

dialogue, although still Shakespearean in nature, is delivered in the context of a world of fast cars, loud music, and a language of violence. Juliet, portrayed by Claire Danes, is similarly updated. No longer just a naïve young woman waiting to be married off, she is portrayed as a more modern, self-aware teenager, one who is not just fighting the constraints of family expectations but is actively seeking her own voice and identity. Through these updated characters, Luhrmann speaks to modern viewers, making the characters' struggles feel familiar, their desires and pain easily understood.

The true essence of Shakespeare's work—the impetuousness of youth, the depth of love, the intense yearning for connection, and the tragic consequences of unchecked violence—is what Luhrmann focuses on. He wisely preserves the original dialogue, allowing Shakespeare's poetic language to remain the emotional heart of the story. This decision, in many ways, is central to the film's success. Luhrmann could have easily abandoned Shakespeare's words in favor of a more modern script or simplified the language to make the

Baz Luhrmann

story more accessible. Instead, he trusted in the enduring power of Shakespeare's dialogue, understanding that while the world in which the characters live may change, the profound emotions they experience transcend time and place.

While the modernization of setting and characters is immediately striking, it is Luhrmann's use of visual and auditory elements that truly makes the film stand out. One of the most distinctive features of his work is his ability to blend style and substance, and Romeo + Juliet is no exception. The film is a sensory experience, filled with striking colors, dramatic lighting, and an eclectic mix of music that runs the gamut from contemporary rock to classical scores. The soundtrack, which includes songs from artists like Radiohead, The Cardigans, and Garbage, becomes an integral part of the storytelling, amplifying the emotional weight of key moments in the film. The energetic and contemporary score captures the spirit of the youth rebellion at the core of the story, making Shakespeare's themes feel as fresh and visceral as if they were written today.

Baz Luhrmann

The use of music in particular is one of Luhrmann's most innovative choices in modernizing Romeo + Juliet. The anachronistic use of rock and pop music, in conjunction with classical compositions, bridges the gap between Shakespeare's Elizabethan world and the modern-day, helping to shape the emotional landscape of the film. Music becomes an emotional language in itself, connecting the modern world with the timeless human experiences of love, pain, and loss. The standout track, "Kissing You" by Des'ree, plays during one of the film's most intimate moments between Romeo and Juliet, and it encapsulates the tenderness of their love amidst the chaos and violence that surrounds them.

Furthermore, Luhrmann's rapid-fire editing style, dynamic camera work, and exaggerated visual motifs heighten the dramatic intensity of the story. Scenes are fast-paced and filled with quick cuts, symbolizing the whirlwind of emotions that the characters experience. This approach emphasizes the chaotic nature of the love affair between Romeo and Juliet—an all-consuming,

Baz Luhrmann

quick-burning passion that cannot last in such a volatile environment. In juxtaposition to the frantic editing, the visual motifs of water and fire, often used to symbolize love and death, further reinforce the tragic inevitability of the narrative.

Ultimately, Baz Luhrmann's concept of modernizing Romeo + Juliet without altering the play's essential elements demonstrates a profound understanding of both the timeless nature of Shakespeare's work and the cultural moment he was working within. By combining the two, he created a version of the play that felt both fresh and eternal—an adaptation that spoke directly to the anxieties, desires, and realities of contemporary life while remaining rooted in the original text's themes. Luhrmann's Romeo + Juliet has stood the test of time not only because it brought Shakespeare to a new generation but because it demonstrated the enduring relevance of the play's core message: the destructive power of hate and the transcendent, often tragic, nature of love.

Baz Luhrmann

Casting and Visual Styling: A Radical Approach

Baz Luhrmann's Romeo + Juliet (1996) is a visual and auditory spectacle that stands out for its bold, radical approach to casting and visual styling. Both elements were central to his vision of reimagining Shakespeare's classic for a modern audience. Luhrmann's choices not only redefined the characters and the aesthetic of the film but also played a crucial role in making the timeless themes of love, violence, and fate feel fresh and immediate.

In terms of casting, Luhrmann made the daring decision to place established actors within the context of a teenage romance, allowing them to breathe new life into Shakespeare's characters. Leonardo DiCaprio, fresh off the heels of his performance in What's Eating Gilbert Grape (1993), was cast as Romeo. DiCaprio's portrayal of Romeo was striking in that he was a departure from the typical suave or aristocratic image often associated

Baz Luhrmann

with the character. Instead of playing Romeo as a noble or princely figure, DiCaprio's version was an angsty, impulsive teenager—a brooding youth, brimming with passion and confusion, whose sense of rebellion echoed through every moment of his performance. This casting choice immediately bridged the generational gap between the Elizabethan audience and the modern youth audience. DiCaprio's star power also played a significant role in attracting a younger demographic to the film, making Shakespeare's play accessible to them on a cultural level, rather than just a literary one.

Similarly, Claire Danes, in her role as Juliet, brought an emotional depth and vulnerability to the character that resonated with a contemporary audience. Danes' portrayal of Juliet as a young woman torn between familial duty and the overwhelming passion of her love for Romeo reflected the universal experience of adolescence—an emotional intensity that is familiar to viewers of all ages. Her portrayal was a departure from the traditional, often passive depiction of Juliet, infusing the character with agency and a sense of self. The

Baz Luhrmann

juxtaposition of Danes' innocent yet assertive portrayal of Juliet and DiCaprio's impetuous Romeo created a sense of youthful urgency in their relationship, making their love feel both intense and fragile in the context of the modern world.

The casting choices of the supporting characters were equally bold, with actors like John Leguizamo, Harold Perrineau, and Paul Rudd contributing memorable performances that expanded on Shakespeare's original roles. John Leguizamo's portrayal of Tybalt, Juliet's fiery cousin, was one of the most striking aspects of the film. Tybalt was reimagined as a charismatic yet menacing character who was at once a villain and a product of his violent environment. Leguizamo's energy and charisma lent the character an intensity that added depth to the rivalry between the Montagues and the Capulets. Similarly, Harold Perrineau's portrayal of Mercutio, Romeo's witty and loyal friend, was a captivating mix of humor and emotional complexity, making him one of the film's standout characters. Mercutio's famous "Queen Mab" speech, for example, became even more layered

Baz Luhrmann

and poignant when presented in the context of Mercutio's own disillusionment and playful yet tragic nature.

The film's visual styling was equally radical, drawing heavily on Luhrmann's trademark aesthetic sensibilities. Known for his flair for the extravagant and for blending period elements with modern pop culture, Luhrmann created a film world that felt both nostalgic and current. The setting of Romeo + Juliet was a hyper-stylized, contemporary version of Verona, one that was heavily influenced by the vibrant, chaotic energy of 1990s urban America. The film's setting—an imagined city full of neon lights, high-rise buildings, and shopping malls—conveyed a sense of excess and cultural fragmentation. It wasn't a realistic depiction of a modern city, but rather an exaggerated, almost surrealist interpretation of contemporary life, where violence and passion seemed to bubble beneath the surface of everyday life. This stylized world was the perfect backdrop for the tragic love story, providing a visual

Baz Luhrmann

metaphor for the intensity and urgency of Romeo and Juliet's doomed romance.

Luhrmann's use of colors, lighting, and camera work further added to the radical visual approach. The film was bathed in bold, saturated colors that heightened the emotional stakes of each scene. The use of vivid yellows, blues, reds, and greens brought an almost comic-book quality to the film, amplifying the emotional extremes the characters experienced. Whether it was the neon glow of the Capulet's party, the fiery red of the Montagues' cars, or the cool blue tones of the tragic final scenes, the color palette played a crucial role in signifying the changing moods and the impending doom of the characters' journey. The saturation of color also helped to evoke a heightened sense of reality, blurring the lines between fantasy and the raw intensity of real emotion.

The film's use of camera angles and movement also contributed to its radical visual style. Quick, jittery camera movements and tight close-ups were used to

Baz Luhrmann

immerse the audience in the characters' emotional worlds, making their thoughts, desires, and conflicts feel immediate and palpable. The rapid editing of the film, particularly in action scenes, contributed to the sense of chaos and instability in the world that Romeo and Juliet inhabited. These stylistic choices helped Luhrmann inject a frenetic energy into the film that echoed the impulsive nature of the characters' love and their inability to control the forces around them. The visual language was also designed to draw parallels between the modern world of guns and violence and the ancient world of swords and duels. The juxtaposition of old and new was best exemplified by the film's reimagining of traditional sword fights, where the characters wielded guns in place of swords. This shift in weaponry symbolized the timeless nature of violence, showing how human conflict evolves but remains fundamentally the same.

One of the most memorable visual aspects of the film was its use of surreal, dreamlike sequences. Luhrmann integrated elements of visual fantasy to bring out the

Baz Luhrmann

heightened emotional states of the characters. For instance, when Romeo and Juliet first meet at the Capulet ball, their introduction is framed as if they are floating in a dream, an ethereal and romantic encounter that uses slow-motion effects, intimate camera angles, and a soft-focus lens to enhance the fairy-tale quality of the moment. Similarly, the final scene of the film, where the lovers' tragic end is played out, is bathed in an almost otherworldly glow, emphasizing the fatalistic nature of their love story.

Luhrmann's radical approach to visual styling and casting was not only a testament to his unique cinematic vision but also a reflection of his understanding that Romeo and Juliet was, at its core, a timeless story of youthful passion, violence, and fate. By updating and stylizing the film in such a dynamic way, Luhrmann invited a new generation to experience Shakespeare's work while also preserving the emotional intensity and beauty of the original play. The film's radical visual and casting choices served to make the tragedy of Romeo and Juliet not just a historical tale, but a story that felt

Baz Luhrmann

immediate, relevant, and profoundly resonant in the context of the modern world.

Music and Symbolism: The Soundtrack as a Narrative Tool

Baz Luhrmann's Romeo + Juliet (1996) is a film that thrives on its rich, evocative use of music and sound, using them as narrative tools that deepen the emotional impact of the story. The soundtrack of the film is more than just an accompaniment to the visuals; it is intricately woven into the fabric of the narrative itself, enhancing the emotional resonance of key moments and underscoring the themes of love, fate, and tragedy. Luhrmann's approach to music and symbolism in Romeo + Juliet was revolutionary, transforming the way soundtracks were perceived and used in cinema.

The soundtrack, carefully curated by Luhrmann and his team, blends modern rock, pop, and classical music,

Baz Luhrmann

creating an eclectic and vibrant soundscape that mirrors the clash of the old and the new in the film's visual style and narrative. The incorporation of contemporary music, from bands like Radiohead, The Cranberries, and Garbage, alongside classical scores from composer Craig Armstrong, gives the film an anachronistic energy, combining the timeless with the contemporary in a way that feels both fresh and nostalgic. This fusion of musical genres mirrors the film's larger thematic exploration of love, violence, and youthful rebellion, making the story feel urgent and immediate to a 1990s audience, while still maintaining the core emotional truths of Shakespeare's original play

One of the most iconic elements of the Romeo + Juliet soundtrack is its use of the song "Lovefool" by The Cardigans, which plays during one of the film's pivotal moments—the first romantic encounter between Romeo and Juliet at the Capulet ball. The song, with its upbeat tempo and yearning lyrics, captures the innocence and intensity of the lovers' immediate attraction to each other. The juxtaposition of the light, catchy melody with

Baz Luhrmann

the weight of the characters' deep emotional connection adds a layer of irony and tension to the moment. The song's lyrics, "I'm a fool for you," reflect Juliet's naïve surrender to her emotions, while also foreshadowing the tragedy to come, as both Romeo and Juliet are doomed to be swept away by forces beyond their control. The use of modern music in this scene effectively shifts the classical romantic moment into a more relatable, youthful context, emphasizing the intensity and impulsiveness of first love.

In another striking example, the film features a remix of "Everybody's Free (To Feel Good)" by Rozalla, a song that originally became popular in the early 1990s. The track is used during the scene where Romeo and Juliet, separated by the constraints of their feuding families, still find moments of ecstatic freedom together. The music's driving beat and positive energy elevate the sense of joy and liberation the characters experience, and the refrain, "Everybody's free to feel good," serves as an ironic commentary on the impossibility of their love being truly free in a world governed by violence and

Baz Luhrmann

familial loyalty. The song's upbeat rhythm underscores the exhilarating feeling of rebellion, yet also signals the tragic nature of their situation. By juxtaposing the soundtrack with the narrative's darker undertones, Luhrmann illustrates how fleeting moments of happiness can be corrupted by the weight of the world.

Throughout Romeo + Juliet, Luhrmann also uses music to enhance the film's sense of heightened emotional states. The juxtaposition of soft, lyrical classical music with explosive rock songs creates a contrast that mirrors the extreme emotions the characters experience. For instance, the dramatic, swirling orchestral compositions that accompany moments of conflict and danger, such as the violent confrontation between the Montagues and the Capulets, serve to heighten the tension and make the violence feel larger-than-life. The swelling strings and heavy percussion create an operatic atmosphere, making the audience feel the inevitability of tragedy in a way that is both emotional and visceral.

Baz Luhrmann

In contrast, during moments of love and connection, the soundtrack shifts to softer, more intimate pieces that underscore the tenderness and vulnerability of Romeo and Juliet's relationship. In particular, the use of Craig Armstrong's composition, "Healing," a hauntingly beautiful instrumental piece, adds a layer of serenity and peace to moments when the lovers are alone, away from the chaos of their families. The strings and piano in the piece offer a subtle contrast to the more chaotic elements of the film, highlighting the fleeting and fragile nature of Romeo and Juliet's love. Armstrong's score, which often combines classical motifs with a modern electronic sound, mirrors the film's visual style, fusing the old and the new in a way that deepens the emotional complexity of the characters' experiences.

The music is also symbolic in how it represents the shifting identities of the characters. Romeo and Juliet, as individuals and as lovers, are continually in flux throughout the film. Their identities are shaped by the violence around them, the expectations of their families, and their growing love for one another. The soundtrack

Baz Luhrmann

reflects this internal transformation, with certain songs evolving in tone or rhythm to mirror their changing emotions. For example, in the iconic scene where Romeo and Juliet's love reaches its zenith during their secret wedding, the music takes on a sweeping, triumphant quality. The symphonic swell of the score captures the emotional release they feel in committing to each other, but it is soon undercut by the dark irony of their doomed fate, subtly hinted at through the film's use of more discordant, foreboding tones.

In terms of symbolism, Luhrmann's use of music goes beyond simply setting the mood; it becomes a key part of the film's narrative structure. In a film about fate and destiny, the soundtrack serves as a reminder of the external forces controlling the characters' lives. The repetition of certain themes or motifs in the music throughout the film builds a sense of inevitability, as if the characters are caught in a larger, uncontrollable force. For example, the recurring use of "Young Hearts Run Free" by Candi Staton, an anthem of youthful defiance, echoes the sense of rebellion against authority

Baz Luhrmann

and tradition that defines the lovers' relationship. The song represents the characters' desire to break free from the constraints of their families and society, but it is also deeply tragic, as their defiance ultimately leads to their downfall.

The film's final sequence, set to the powerful and haunting "Exit Music (For a Film)" by Radiohead, is a culmination of Luhrmann's use of music and symbolism. The song's somber tone, paired with the tragic images of Romeo and Juliet's deaths, underscores the inevitability of their fate. The track's melancholy lyrics—"We hope that you choke"—capture the anguish and helplessness of the characters as they face the consequences of their actions, and the haunting melody adds a layer of despair and finality to the film's tragic conclusion. This choice of music symbolizes the disconnect between the characters' desires and the harsh realities of their lives, offering a profound commentary on the tragic consequences of living in a world ruled by violence and family loyalty.

Baz Luhrmann

In conclusion, the soundtrack of Romeo + Juliet is an integral part of the film's identity and serves as a narrative tool that enhances both the emotional and symbolic depth of the story. Through the careful selection of music—from contemporary pop and rock to orchestral arrangements—Luhrmann not only adds layers to the story but also reinterprets Shakespeare's themes for a modern audience. Music becomes a means of expressing the inner emotional turmoil of the characters, reflecting their desires, fears, and rebellion, while also acting as a symbolic reminder of the forces that shape their destinies. The soundtrack of Romeo + Juliet is a perfect example of how music can be used in cinema not just to accompany images, but to amplify and deepen the storytelling, creating a multisensory experience that resonates with audiences on a profound emotional level.

Baz Luhrmann

CHAPTER 4: MOULIN ROUGE! (2001) – A MARRIAGE OF MUSIC AND FANTASY

Baz Luhrmann's Moulin Rouge! (2001) is a film that redefines the concept of a modern musical, blending a rich tapestry of music, vibrant visuals, and high-energy performances with the timeless allure of fantasy. It's a work that pushes the boundaries of genre, creating a unique cinematic experience that transcends traditional storytelling to create something both nostalgic and revolutionary. One of the key elements that define Moulin Rouge! is its marriage of music and fantasy, a fusion that serves as both a narrative device and a reflection of the emotional arcs of the characters. The film uses music not only as a form of entertainment but as an essential tool for storytelling, imbued with deep symbolism and emotional weight.

The plot of Moulin Rouge! revolves around Christian, a young poet who falls in love with Satine, a beautiful

Baz Luhrmann

courtesan and the star of the titular Parisian nightclub. Set in the bohemian world of the late 19th century, the film brings to life a world filled with passion, love, betrayal, and tragedy. However, what makes Moulin Rouge! stand out is not just its dramatic plot but its audacious use of music. By blending classic songs from different genres with original compositions, Luhrmann creates a world where music becomes the primary emotional language, guiding the audience through the turbulent, whirlwind romance of Christian and Satine.

Luhrmann's decision to use pre-existing pop songs alongside the original score is a key part of how Moulin Rouge! merges music with fantasy. The songs are re-imagined in the context of the narrative, making them more than just a backdrop to the action. They are used to express the internal emotional states of the characters and highlight the surreal nature of the world they inhabit. The soundtrack includes a mix of contemporary songs, from Elton John's "Your Song" to David Bowie's "Nature Boy," alongside modern renditions of older classics, such as "Roxanne" by The Police. These songs

Baz Luhrmann

become expressions of the characters' feelings, desires, and struggles, creating a seamless connection between the world of the film and the audience's contemporary experience.

One of the standout aspects of Moulin Rouge! is its ability to blend disparate musical genres and cultural references into a cohesive narrative. The soundtrack mixes opera, rock, pop, and cabaret, creating a sense of a fantastical world where anything is possible. The juxtaposition of different musical styles enhances the film's surreal atmosphere, amplifying the emotional highs and lows of the story. For example, the dramatic love duet "Come What May," which represents Christian and Satine's devotion to each other, is counterbalanced by the more playful and seductive "Lady Marmalade," performed by Christina Aguilera, Lil' Kim, Mýa, and Pink, which speaks to the darker, more dangerous allure of Satine's world at the Moulin Rouge. The contrast between these songs underscores the duality of the characters' lives—the pure love they strive for and the hedonistic world they are both a part of.

Baz Luhrmann

Beyond the integration of music, Luhrmann also utilizes fantasy elements to deepen the emotional impact of the story. The world of Moulin Rouge! is not grounded in realism but rather in a heightened, dreamlike space where emotions are magnified and everything feels possible. The setting itself— a lavish, vibrant, and often chaotic nightclub—is an embodiment of the film's central theme: the collision of love and fantasy. The fantastical set design, with its larger-than-life imagery, mirrors the way the characters view their own experiences, often through the lens of illusion or fantasy. For example, in the film's opening sequence, we are introduced to the world of the Moulin Rouge, a place filled with dazzling lights, extravagant costumes, and over-the-top performances. This heightened visual style, which includes rich reds, glittering golds, and surreal lighting, makes the world feel more like a dream than a tangible reality, emphasizing the film's exploration of the characters' desires and their capacity for imagination.

Baz Luhrmann

The visual elements of the film play an important role in supporting the music's emotional power. Luhrmann uses rapid editing, sweeping camera movements, and vivid color schemes to create a sense of energy and movement that mirrors the music's intensity. In many ways, the film's visuals serve as an extension of its musicality. The way the camera swirls around the dancers, the intricate set designs, and the kaleidoscopic color palette combine to create a visually stimulating experience, one that feels like a constant sensory overload. This hyper-stylized world mirrors the characters' emotional states—especially Satine's tragic journey as she navigates between love and survival. Her inner turmoil and the unreal nature of her relationship with Christian are reflected in the world around her, which fluctuates between opulence and disillusionment.

Moulin Rouge! also explores the relationship between love and illusion, using the world of theater and performance to reflect how love can be both transformative and deceptive. The characters often exist in a world of fantasy, where love is idealized and

Baz Luhrmann

projected onto a larger-than-life stage. For example, Christian, the poet, initially views Satine through the lens of his idealized version of love, seeing her as the perfect object of his romantic fantasies. However, as their relationship deepens, the tension between their dreams and the harsh realities of their lives comes to the forefront. Satine, too, is caught between the roles she plays on stage and her own desires for love and escape. The film's use of extravagant musical numbers, such as the opulent "Spectacular Spectacular," highlights the idea of love as performance, as a fantasy that can be constructed, shattered, and re-imagined.

The themes of love and fantasy in Moulin Rouge! are also deeply intertwined with the notion of sacrifice and the price of pursuing one's dreams. Satine's character represents the struggle between personal aspiration and the compromises she is forced to make in order to survive in the harsh world of the Moulin Rouge. Her journey is marked by moments of hope and despair, which are mirrored in the film's musical choices. The emotional crescendo of "Come What May," the love

theme between Christian and Satine, contrasts sharply with the tragic realization that their love may not survive the circumstances of their world.

The film's conclusion, set to "Come What May," is an emotional and visual culmination of the themes of love, sacrifice, and fantasy. The dreamlike quality of the visuals, combined with the soaring power of the music, creates an emotionally charged moment that transcends the confines of the film's narrative. It is a moment of triumph and heartbreak, as the love between Christian and Satine ultimately proves to be both beautiful and impossible. Their love is a fleeting moment in a world of illusion, a moment of fantasy that cannot escape the harshness of reality. In this way, Moulin Rouge! is a meditation on the fragility of love, the power of dreams, and the price one pays for pursuing them.

In conclusion, Moulin Rouge! is a film that uses the marriage of music and fantasy to create an immersive, emotional experience for its audience. Luhrmann's unique approach to integrating modern music with visual

Baz Luhrmann

spectacle creates a world that is both dreamlike and grounded in the emotional truths of its characters. The use of music as a narrative tool—along with the fantastical setting and visual style—allows the film to explore the themes of love, sacrifice, and illusion in a way that is both powerful and poignant. By blending these elements, Luhrmann creates a cinematic experience that is as much about the emotions the characters experience as it is about the world they inhabit, making Moulin Rouge! a true marriage of music, fantasy, and cinematic art.

The Role of Music and Artifice in Storytelling

In Baz Luhrmann's body of work, music and artifice play a pivotal role in his distinctive storytelling style, one that combines vibrant visuals, modern music, and emotional depth to craft narratives that feel both heightened and intimate. Luhrmann's films are known

Baz Luhrmann

for their energetic pacing, grand visuals, and, perhaps most notably, their deep integration of music as an emotional and narrative tool. Whether he's reimagining a Shakespearean classic in Romeo + Juliet (1996), creating a lavish, surreal world in Moulin Rouge! (2001), or presenting the epic historical drama of The Great Gatsby (2013), Luhrmann uses music and artifice not just as embellishments but as essential elements of his stories. These tools allow him to blur the line between reality and fantasy, heighten emotional stakes, and communicate the internal lives of his characters in ways that traditional dialogue or exposition cannot.

A central theme that emerges across Luhrmann's works is the juxtaposition of realism and artifice. The worlds he creates are often exaggerated, vibrant, and full of theatrical flourishes, but it is within these stylized environments that the most genuine emotional connections take place. In Luhrmann's films, the constructed nature of the world itself often reflects the inner lives of the characters, and this is most apparent in the use of music and artifice. He presents his characters'

Baz Luhrmann

emotions and struggles through grand, over-the-top spectacles, drawing attention to the artifice of the world they inhabit. This technique allows for a deeper engagement with the emotional core of the story, as the audience is asked to view the characters' experiences from within a heightened, almost dreamlike frame.

Music in Luhrmann's films serves multiple functions. It is not simply a soundtrack; it becomes a central character in its own right, guiding the viewer through the narrative and setting the emotional tone for each scene. The careful selection and re-imagining of songs play a significant part in how the audience is meant to engage with the characters and their journeys. In Moulin Rouge!, for example, Luhrmann uses a mixture of contemporary pop songs and classic ballads, turning these familiar tunes into emotional expressions of love, desire, heartbreak, and longing. The soundtrack becomes a direct reflection of the characters' inner worlds, a way to articulate their experiences when words alone would fall short. Songs like "Your Song" by Elton John and "Like a Virgin" by Madonna are reinterpreted, their

Baz Luhrmann

meanings shaped by the emotional dynamics of the characters. Music becomes the heartbeat of the narrative, the lens through which the audience understands the depth of the characters' emotions, dreams, and conflicts.

In addition to music, artifice—whether it be through elaborate set design, costume choices, or theatrical visual effects—further amplifies the emotional experience. In The Great Gatsby, for instance, Luhrmann uses an artifice-laden visual style to mirror the opulence and excess of the Jazz Age. The lavish parties at Gatsby's mansion are a visual representation of the American Dream's superficial allure. While the parties are glamorous and colorful, they are ultimately empty, a symbol of the characters' pursuit of hollow desires. The artificial beauty of these settings reflects the illusionary world of wealth and status that Gatsby, Daisy, and the others inhabit. This dissonance between the visual splendor and the emotional emptiness they experience creates a critique of materialism and the fragility of dreams. Artifice, then, is not just a tool for aesthetic

Baz Luhrmann

enjoyment but serves as a critical commentary on the characters' existential struggles.

Similarly, Luhrmann's use of artifice in Romeo + Juliet creates a world that feels both timeless and contemporary. By placing Shakespeare's dialogue in a modern setting, complete with guns, street gangs, and the vibrant chaos of Verona Beach, he underscores the universality of the play's themes while also showing the ways in which they remain relevant in a modern context. The excessive use of visual flourishes—such as the overblown, extravagant costumes, the rapid cuts between scenes, and the heightened emotional performances—emphasizes the artificiality of the world, drawing attention to the constructed nature of the story. Yet, despite the theatricality and exaggeration, the love story at the heart of the film remains intensely real, grounded in the raw emotions of the young lovers.

In Luhrmann's world, the relationship between music, artifice, and emotion is a central tenet of his approach to storytelling. The excesses of the visual world are never

Baz Luhrmann

simply for spectacle; they are designed to mirror the emotional intensity of the characters and themes. For example, in Moulin Rouge!, the constantly shifting scenes—from the dizzying heights of the nightclub's stage performances to the intimate, heartbreaking moments between Christian and Satine—are underscored by music that not only propels the narrative forward but also amplifies the emotional stakes. The colorful costumes, surreal settings, and dreamlike editing all contribute to the feeling that the world of Moulin Rouge! exists as an exaggerated dream, one where love, art, and loss are experienced in their most heightened forms. The fantasy of the world, in this case, is reflective of the dreamlike nature of love itself, and music becomes the vehicle that transports the audience into that heightened emotional space.

In his work, Luhrmann also uses music and artifice to explore the tension between reality and illusion. In The Great Gatsby, for example, the music—particularly the modernized jazz and hip-hop tracks—blurs the lines between the past and the present. The artifice of the

Baz Luhrmann

1920s setting, with its extravagant parties and stylized visuals, contrasts sharply with the deeper sadness and futility experienced by Gatsby. Luhrmann's visual extravagance creates a dissonance between the surface glamour of the story and the emptiness at its core, suggesting that the pursuit of unattainable ideals—whether in love, wealth, or identity—can often result in disillusionment. The vibrant soundtrack and stunning visuals accentuate the superficial nature of the world the characters inhabit, all while allowing the deeper emotional resonance of the story to come through.

The role of artifice in Luhrmann's films also speaks to the idea of transformation and the malleability of identity. His characters often live in worlds where their self-presentation is as important as their inner realities. In Moulin Rouge!, Satine's ability to transform herself from a courtesan into a symbol of love and purity is underscored by her performances on stage. Her costumes, her makeup, and the artifice of the Moulin Rouge all contribute to her constructed identity. Yet,

Baz Luhrmann

beneath this exterior, there is a real woman struggling with love, fear, and loss. The film's visual style, which places heavy emphasis on costume and performance, highlights the tension between the persona Satine presents to the world and her vulnerability as a person. Artifice in this context is both a shield and a prison, allowing characters to transcend their circumstances while also trapping them within the roles they must play.

In summary, music and artifice are not merely decorative elements in Baz Luhrmann's films; they are integral to his storytelling process. Through his innovative use of music, Luhrmann is able to express his characters' internal landscapes, turning songs into emotional shorthand that resonates with the audience. Similarly, the artifice that pervades his films—whether in the form of extravagant costumes, dreamlike visuals, or modernized interpretations of classic stories—creates a heightened reality that reflects the emotional and thematic undercurrents of the narrative. In this way, music and artifice become the language of his cinema, elevating the

Baz Luhrmann

characters' stories and exploring themes of love, desire, sacrifice, and the collision of reality and illusion.

Iconic Performances: Nicole Kidman and Ewan McGregor

Baz Luhrmann's films are often distinguished by their larger-than-life performances, where the actors take on roles that transcend the ordinary, embracing heightened emotion and theatricality. Two of the most iconic performances in Luhrmann's body of work come from Nicole Kidman and Ewan McGregor, whose portrayals in Moulin Rouge! (2001) stand as pillars of both emotional depth and stylistic excess. Their portrayals of Satine and Christian in the film not only define the movie but also solidify their roles in the broader landscape of contemporary cinema. Their performances are integral to the film's success, transforming the script and visual spectacle into a deeply emotional and unforgettable experience.

Baz Luhrmann

Nicole Kidman's portrayal of Satine, the glamorous courtesan at the Moulin Rouge, is both breathtaking and heartbreaking. Kidman's ability to balance Satine's role as both an icon of beauty and a woman filled with vulnerability is key to her performance. Satine is caught between two worlds: the opulent, glamorous world of the Moulin Rouge, where she is expected to sell her beauty and charm, and the internal world of a woman who longs for love and escape from the suffocating grip of her circumstances. Kidman's portrayal embodies both the public persona of Satine and the private, fragile woman struggling with her own desires and limitations.

One of the standout qualities of Kidman's performance is her ability to embody the tragedy of the character without losing the allure and power of Satine's star persona. Kidman's portrayal taps into the duality of the character—someone who can seduce with a glance, yet who is secretly yearning for something more than a life of superficiality. Through her physicality, vocal inflections, and emotional range, Kidman allows Satine's

vulnerability to shine through, especially in scenes where the character's internal conflict is most apparent. Her singing performances, particularly in the showstopping number "Come What May," become a window into Satine's deepest emotions. Kidman's voice, while not traditionally operatic, carries a rawness and sincerity that makes the songs feel authentic, even as the world around her remains a heightened fantasy.

Ewan McGregor, who plays the idealistic and naive writer Christian, brings a similarly layered performance to his role. Christian is the character who falls in love with Satine, and McGregor's portrayal is the embodiment of passion, longing, and youthful optimism. Christian is an outsider to the world of the Moulin Rouge, and McGregor plays this role with a mixture of innocence and determination. His performance creates a palpable contrast to the more cynical world of Satine and the other characters at the Moulin Rouge, capturing the purity and idealism of someone who believes that love can conquer all. McGregor's role also hinges on his ability to connect emotionally with Kidman's Satine, and

Baz Luhrmann

the chemistry between the two actors is undeniable. Their love story is one of doomed beauty, and McGregor's earnestness as Christian brings a sense of authenticity to the emotional core of the film.

McGregor's portrayal is equally multifaceted. While Christian is the dreamer and the romantic, McGregor is able to convey the darker, more complex aspects of the character's journey. As the film progresses, Christian's idealism begins to clash with the harsh realities of Satine's world. McGregor shows this internal struggle with subtlety, shifting from a man full of hope and innocence to one grappling with the painful realization that love might not be enough to overcome the obstacles before him. His performance deepens as the stakes rise, particularly in the scenes leading up to the tragic climax, where his heartbreak is palpable. McGregor's vulnerability as Christian helps anchor the emotional weight of the film, making the love story all the more powerful and devastating.

Baz Luhrmann

What truly elevates their performances is their chemistry, which is electric and emotionally charged. The connection between Kidman and McGregor is both palpable and essential to the film's success. Their portrayals of Satine and Christian are rich with passion, and the audience can feel the intensity of their love, even when it is marred by deceit, sacrifice, and tragedy. Luhrmann's direction plays a huge role in ensuring that their relationship never feels one-dimensional. The characters are not just two people in love; they are two people fighting against everything that stands in the way of their dreams of love. The emotional stakes of their relationship are heightened by their performances, with each actor bringing a unique vulnerability and strength to their roles.

One of the key elements of both Kidman's and McGregor's performances is their ability to navigate the intricate balance between the film's fantastical world and the emotional realism of their characters. In a movie where the visuals are loud, the colors are saturated, and the musical numbers are larger than life, it would have

Baz Luhrmann

been easy for their performances to be lost in the spectacle. However, Kidman and McGregor both manage to ground their characters in real, palpable emotions. Satine's desperation to escape her life as a courtesan, and Christian's desperate yearning to make their love real, resonate deeply with the audience, even amidst the extravagant set designs and dreamlike cinematography.

Their performances also reflect Luhrmann's larger filmmaking philosophy. In his world, nothing is quite as it seems, yet everything feels deeply sincere. Satine and Christian exist in a world of glitter and glamour, but their emotions are raw and real. The artifice of the world surrounding them serves as a backdrop for their intense personal struggles. Kidman's and McGregor's ability to bring these emotional struggles to life within the surreal context of the Moulin Rouge is a testament to their skill as actors. They are able to embody the characters' emotions without succumbing to the overwhelming extravagance of the setting. This combination of style

Baz Luhrmann

and substance is what makes their performances so iconic.

The lasting impact of their performances extends beyond Moulin Rouge! as well. Kidman's portrayal of Satine is one of the defining roles of her career, showcasing her range as an actress who can navigate both the light and dark sides of a character. The role helped cement her status as a leading lady in Hollywood, demonstrating her ability to bring depth and complexity to roles that could have easily veered into the realm of stereotype. For McGregor, his portrayal of Christian allowed him to showcase his emotional range and musical abilities, opening up new avenues in his career and helping to establish him as a versatile actor with a capacity for both drama and comedy.

In the context of Luhrmann's broader body of work, Kidman and McGregor's performances in Moulin Rouge! represent the pinnacle of his approach to casting. He has a unique ability to choose actors who can navigate the emotional extremes of his films, delivering

Baz Luhrmann

performances that are both sincere and over-the-top. Kidman and McGregor were the perfect choices for Moulin Rouge!, as their ability to balance pathos and spectacle helped make the film an unforgettable experience. Their performances transcend the confines of the film, becoming cultural touchstones that continue to resonate with audiences. Together, they brought to life one of the most memorable love stories in modern cinema, and their work in Moulin Rouge! remains an exemplary demonstration of the power of iconic performances.

Baz Luhrmann

CHAPTER 5: AUSTRALIA (2008) – A CINEMATIC EPIC

Australia (2008) stands as one of Baz Luhrmann's most ambitious and sweeping cinematic ventures, a film that blends historical drama, romance, and adventure on an epic scale. Set against the backdrop of the Australian Outback during World War II, the film is a grand exploration of love, loyalty, and the scars of history. Luhrmann's vision for Australia was to create a sweeping, old-fashioned epic in the tradition of the classic Hollywood films of the 1950s, while still infusing it with his signature style—visual grandeur, vibrant color schemes, and a distinctive blend of music and emotion. The result is a film that is both a nostalgic homage to the past and a distinctly modern reimagining of the epic genre.

At the heart of Australia is the relationship between Lady Sarah Ashley, played by Nicole Kidman, and the

Baz Luhrmann

rugged cattle driver, Drover, portrayed by Hugh Jackman. The film begins with Sarah's arrival in Australia from England, where she inherits her late husband's cattle ranch, Faraway Downs. Sarah, initially a stranger to the harsh and unforgiving landscape of the Australian Outback, must learn to navigate the world of cattle-driving, while also grappling with her personal grief and transformation. Drover, a man with a deep connection to the land and a past filled with personal demons, is hired to help Sarah transport the cattle across the Outback, setting the stage for their complex relationship.

What follows is a cinematic journey through the stunning Australian landscape, marked by moments of breathtaking visual splendor. Luhrmann uses the vastness and rugged beauty of the Outback not just as a setting, but as a character in its own right, shaping the events and emotional arcs of the characters. The landscape is at once beautiful and perilous, a perfect metaphor for the challenges that Sarah and Drover face in their personal and collective journeys. Luhrmann's use

Baz Luhrmann

of vivid colors, sweeping cinematography, and grandiose visual style elevates the film into a cinematic experience that feels both intimate and monumental. The expansive vistas of the Australian wilderness become more than just a backdrop; they serve as a constant reminder of the forces of nature that are both liberating and destructive.

The story of Australia is deeply intertwined with the history of the country itself, particularly in its depiction of the treatment of Indigenous Australians. One of the central plotlines involves the character of Nullah, a young half-Aboriginal boy played by Brandon Walters. Nullah's journey represents the struggle of Indigenous Australians during this period, caught between two worlds—the white, colonial world that seeks to erase their culture, and the traditions of his Aboriginal heritage that are in danger of being lost. The film explores the prejudice and systemic injustice faced by Aboriginal people, especially during the time of the "Stolen Generations," when children of mixed-race heritage were forcibly removed from their families by the Australian government. Nullah's quest for identity and belonging

Baz Luhrmann

becomes an emotional anchor for the film, as Sarah and Drover ultimately try to protect him from the forces that seek to separate them.

Luhrmann's exploration of race and identity is an ambitious and poignant aspect of Australia, offering a nuanced portrayal of the tensions between colonization, tradition, and the struggle for justice. Through Nullah's story, the film critiques the treatment of Indigenous Australians while highlighting the importance of family and connection to the land. In this sense, Australia is as much about the personal journeys of its characters as it is about the national history and collective memory of Australia. Luhrmann weaves these elements into a sprawling narrative that spans across a number of genres, from historical epic to romance to adventure, all while staying rooted in the themes of love, loss, and the search for identity.

The film's visual style is as much a character as its human protagonists. Luhrmann brings his trademark flair for maximalist visuals to the production, using bold

Baz Luhrmann

colors, sweeping camera movements, and dramatic lighting to create a sense of grandeur and urgency. From the opening sequence, with its vivid shots of the Outback's sun-drenched landscape, to the more intimate moments of the characters in the pastoral settings of Faraway Downs, the film constantly shifts in tone and scale, mirroring the emotional highs and lows of its characters. This visual dynamism is also underscored by the film's use of CGI and practical effects, particularly in the action sequences, which are filled with breathtaking moments of danger and heroism.

A significant aspect of Australia is its thematic focus on family and belonging. As Sarah Ashley embarks on her journey of personal transformation, her relationship with Nullah becomes a central narrative thread. Nullah is not only the key to unlocking the film's emotional core but also the symbol of the untapped potential of Australia's future. In her quest to protect him, Sarah ultimately discovers her own sense of purpose and connection to the land. Similarly, Drover's relationship with Nullah—and his evolving feelings toward Sarah—form

Baz Luhrmann

the basis of the romantic subplot. This interplay between romance, responsibility, and the longing for familial bonds is underscored by a central theme of reconciliation, both within the context of individual relationships and the broader, more complex cultural reconciliation of Australia's history.

Australia also stands out for its use of music, which plays an integral role in shaping the mood and emotional resonance of the film. The soundtrack, which combines classical orchestration with contemporary music, is used to enhance the film's sweeping narrative and underscore the dramatic moments of tension and triumph. The score, composed by David Hirschfelder, is both grand and intimate, capturing the sweeping grandeur of the Australian Outback while also highlighting the personal stakes of the characters' journeys. The inclusion of various Australian songs, including the iconic "Over the Rainbow," helps to ground the film in its specific cultural context while adding to the overall sense of nostalgia and myth-making.

Baz Luhrmann

The film's success and its reception were mixed, with some critics praising its bold ambition and visual splendor, while others criticized its sprawling narrative and pacing. However, Australia ultimately became a cultural touchstone for its portrayal of Australian identity, as well as its exploration of the country's colonial past. Despite its mixed reception, the film's emotional impact, visual innovation, and thematic depth solidified its place as a modern epic, one that seeks to challenge and redefine the idea of the cinematic adventure.

In many ways, Australia represents Baz Luhrmann's foray into the realm of the classical epic, one where his signature visual flair and heightened emotional storytelling meet a more traditional narrative structure. The result is a film that is both larger than life and deeply personal, telling the story of a nation, a people, and a love that transcends borders. Luhrmann's Australia may not have garnered universal critical acclaim, but it undeniably remains a testament to his audacious

Baz Luhrmann

approach to filmmaking, marking a bold chapter in his career as a director and storyteller.

Reception and Analysis: A Commercial and Critical Crossroad

The reception of Australia marked a significant turning point in Baz Luhrmann's career, presenting both commercial challenges and critical debates over his creative approach. While Australia was envisioned as a grand, cinematic tribute to the filmmaker's homeland, reactions to the film were notably divided, with some critics and audiences embracing its ambition, while others were less convinced by its sprawling narrative and stylistic choices. This mixed response positioned Australia at an intriguing intersection of commercial appeal and critical scrutiny, as audiences around the world reacted differently to Luhrmann's uniquely stylized approach to epic storytelling.

Baz Luhrmann

One of the most striking aspects of Australia's reception was its polarizing effect on critics. In the lead-up to the film's release, Australia had generated considerable buzz due to Luhrmann's reputation and the star power of Nicole Kidman and Hugh Jackman. However, after the film premiered, reviews ranged widely from high praise to outright criticism. For some critics, Australia was an exceptional cinematic achievement, an audacious effort to recapture the grandeur of classic Hollywood epics with a distinctly Australian twist. These positive reviews often highlighted the film's breathtaking visuals, Luhrmann's daring artistic direction, and the emotionally charged performances of its leads.

Yet, a substantial segment of critics found fault with what they saw as an overly ambitious narrative, suggesting that the film's epic scale came at the cost of coherence. For these reviewers, Australia's attempt to blend romance, adventure, historical drama, and social commentary felt too sprawling, making the narrative appear disjointed at times. Some critics argued that the film's length—over two and a half hours—contributed to

Baz Luhrmann

a pacing issue, detracting from the impact of individual storylines and leading to moments of melodrama. Luhrmann's preference for visual spectacle and grandiose storytelling, though celebrated by some, was seen by others as excessive, adding unnecessary weight to an already complex plot.

The film's commercial performance added further layers to the conversation surrounding its impact. Australia opened with strong box office numbers, partly due to the anticipation surrounding Luhrmann's first film since Moulin Rouge! and the widespread appeal of its lead actors. The film's initial success was buoyed by audiences drawn to its combination of romance, adventure, and lush cinematography. However, while it performed well initially, it struggled to sustain momentum in certain markets, particularly in the United States, where its stylized approach and specific cultural references didn't resonate as strongly with all viewers. Despite this, Australia did enjoy notable success in other regions, particularly in Australia and Europe, where

Baz Luhrmann

Luhrmann's take on historical and cultural themes found a more receptive audience.

The reception in Australia was particularly significant, as Luhrmann's attempt to portray aspects of the country's history and identity gave the film a unique resonance among Australian audiences. For many Australians, the film's focus on themes like the "Stolen Generations"—the forced removal of Aboriginal children from their families—was an important acknowledgement of painful parts of the country's past. This thematic element sparked conversations in Australia about representation, reconciliation, and national identity, leading some to view Australia as a landmark film despite its polarizing critical reception. Luhrmann's decision to place the experiences of Aboriginal Australians at the center of his narrative was generally well-received in Australia, even if the portrayal faced criticism from some quarters for oversimplifying complex social issues. For many, however, it represented a step toward addressing historical injustices and

Baz Luhrmann

broadening cinematic portrayals of Australia's cultural heritage.

Globally, however, Australia faced more varied responses, as the film's Australian-specific historical references and cultural themes didn't always translate easily to international audiences. Some international viewers, unfamiliar with the historical context, found the plot harder to engage with on an emotional level. Others, however, saw the film as a visually stunning love letter to the Australian landscape and culture, with Luhrmann's romanticized vision of the Outback, cattle drives, and wartime challenges resonating as an exotic, adventurous experience. As a result, Australia became a film that appealed to niche audiences in various regions rather than achieving the broad, universal success Luhrmann might have initially anticipated.

Despite the criticisms, Australia has since garnered a degree of respect within film discourse for its bold artistic vision and complex themes. Over time, some critics who were initially skeptical began to reassess the

Baz Luhrmann

film's place in Luhrmann's filmography and the broader cinematic landscape. From a thematic perspective, Australia's exploration of cultural identity, historical trauma, and personal resilience resonated more deeply as cultural conversations around Indigenous rights and historical acknowledgment gained prominence in the years following the film's release. In this light, the film's willingness to confront and dramatize a difficult chapter in Australian history is often viewed as a valuable, if imperfect, attempt to broaden mainstream narratives about the country's past.

The visual style of Australia has also aged well in the eyes of some critics, who now appreciate Luhrmann's use of color, composition, and CGI-enhanced landscapes as a part of his larger-than-life aesthetic. Luhrmann's depiction of the Outback, with its vibrant color palette and sweeping, almost surreal scenes, has been recognized as a powerful visual experience, one that echoes the awe-inspiring landscapes of classic epics while providing a uniquely Australian sense of place. The film's design, influenced by Luhrmann's

Baz Luhrmann

background in theater and opera, showcases his skill in blending heightened realism with fantasy, even if this stylization didn't resonate with everyone upon release.

In summary, the reception of Australia represents one of the most complex critical and commercial intersections in Baz Luhrmann's career. The film's ambitious vision, bold thematic choices, and lush cinematography garnered both admiration and critique, positioning it as a divisive yet culturally significant entry in Luhrmann's body of work. While the initial response was mixed, Australia has come to be appreciated by a segment of critics and viewers for its daring scope and willingness to confront difficult topics. It serves as a testament to Luhrmann's creative audacity, underscoring his determination to tell stories that challenge conventional narratives and celebrate the extraordinary in both history and art. In the years following its release, Australia has emerged as a complex and layered piece of cinema, a film that continues to inspire discussions about storytelling, representation, and the power of cinematic spectacle.

Baz Luhrmann

CONCLUSION

Baz Luhrmann's journey through the world of cinema has been nothing short of transformative. In a career spanning over three decades, he has not only redefined storytelling but has also proven that classic narratives can be reinterpreted in bold, innovative ways that speak to audiences across generations. By fusing the timeless with the contemporary, Luhrmann has created a cinematic language uniquely his own—a language that celebrates drama, color, and emotion in their most heightened forms. His work reminds us that art is not just about recounting a story; it's about reawakening it in ways that resonate with the modern world while honoring its origins.

From the romance of Romeo + Juliet to the dazzling decadence of Moulin Rouge! and the haunting nostalgia of The Great Gatsby, Luhrmann has never shied away from challenging conventions. His films invite us to step into a dreamscape where sound, color, and movement

Baz Luhrmann

come alive in ways that move us deeply. Through his talent, he reintroduces audiences to the beauty and tragedy of love, the allure of ambition, and the power of art to capture the complexities of human experience.

In Baz Luhrmann: Reimagining Classics for a New Generation – Cinematic Extravagance, we have journeyed through the creative vision, determination, and sheer passion that define his work. Luhrmann's impact on cinema will continue to shape how future generations see not only the stories he's retold but the very art of filmmaking itself. He has shown that to truly capture an audience, one must dare to break the rules and to create worlds where the ordinary becomes extraordinary.

As Luhrmann's career progresses, his legacy as a master of cinematic extravagance will endure, inspiring new storytellers to push boundaries and make the classics their own. His films are more than visual masterpieces; they are celebrations of love, loss, and the undying spirit of creativity. Baz Luhrmann has redefined what it means to be a filmmaker in the modern age, and his work will

Baz Luhrmann

remain a beacon of innovation and passion—a testament to what's possible when one has the courage to dream and the artistry to turn those dreams into unforgettable experiences.

www.ingramcontent.com/pod-product-compliance
Lightning Source LLC
Chambersburg PA
CBHW070423240526
45472CB00020B/1176